PHOTOGRAPH READING AND INTERPRETATION

WRITEN BY: Frank Philemon
P.O.Box, 116,
Liwale-Lindi,
TANZANIA.
+255762426746
naxfra@gmail.com
© 2017

All rights are reserved. No part of this book may be reproduced, stored in retrieval system, photocopying, recording or transmitted in any means, including electronics, magnetics, or otherwise without prior written permission of the writer.

Copyright © 2017 by Frank Philemon

FRANK PHILEMON

TABLE OF CONTENTS

CHAPTERS. **PAGES.**

ACKNOWLEDGEMENT ... 03

PREFACE.. 04

TABLE OF CONTENTS .. 02

DEDICATION ... 05

CHAPTER 01:
GENERAL CONCEPT ... 06

CHAPTER 02:
INTRODUCTION TO PHOTOGRAPH.. 09

CHAPTER 03:
TYPES AND FEATURES OF PHOTOGRAPHS 12

CHAPTER 04:
PHOTOGRAPH READING AND INTERPRETATION......................... 24

CHAPTER 05:
IN-DEPTH STUDY OF AERIAL PHOTOGRAPH............................... 36

CHAPTER 06:
SCALES AND AREA MEASUREMENTS IN AIR PHOTOGRAPHS 49

TRIAL QUESTIONS: ... 66

BIBLIOGRAPHY: .. 68

ACKNOWLEDGEMENT

The work of this book is a result of direct and indirect support and contribution of many people in which I sincerely extend my special thanks to them for their efforts, contributions and supports in order to complete the work of this book. I also extend my gratitude to the Heavenly almighty God for His protection and blessings to my life and my family.

Other special thanks I extend to my lovely wife, Mariam Lucas and students at Liwale Day Secondary School as well as Naxfra Mixed Education Enrichment for extending their hearts and hands so as to accomplishing the work of this book. Amazon Company is the last but the least. Thank you for sacrificing your comfort and rights the greater good.

God bless you all the individuals who have in their personal and official capacity, contributed in one way or another for realization of this book. I sincerely acknowledge; without your effort this book would not have seen the light of day.

PREFACE

Photograph Reading and Interpretation is the simplified book of basic concepts about Photograph. This makes its content easily accessible to all geographers, photographers and students in secondary schools, colleges and universities. The author is confident that this book will be an invaluable asset for schools, colleges and universities and that students as well as teachers and lecturers will find it useful in making the teaching and learning process easier, pleasant and more fruitful.

Any efforts and contribution in one way or another incurred by all people in order to complete the work of this book is acknowledged; without their support this book would not have been written or published and seen by all of the people of the universe. I acknowledge all writers that I used their books as references to write the work of this book.

Frank Philemon.
 Author.
 © 2017

DEDICATION

This book I specially dedicate to the one much I adore, whom I mostly love; my beautiful wife **Mariam Lucas** in her great and strong support on my side since I married her. She have been a blessing through giving me an opportunity of writing books so as to share my knowledge and talent with other people arround the world. May the Heavenly Father bless and grant her long life.

CHAPTER ONE

GENERAL CONCEPT

Etimologically, the word photograph is derived from two Greek words: *"phao"* meaning *'light'* and *"graphê"* meaning *'drawing'* or *'writing'*; together these two words mean as to *"drawing with light"* or *"writing with light"*. Photograph as other field of study has a lot of teminologies used to complete the subject matter; the following are some of them defined terms as used in the study of photograph: ***Photograph*** is an image or picture of an object that recorded by camera and then printed on a paper. Also reffered as the real image of an object which shows both man and natural features as well as human activities taken by camera.

Camera is an equipment or device used in taking photograph. ***Film*** is a dark plastic-like material which can record images as photographs or as a moving picture. ***Photograph Reading*** is the process of examination photographic print in order to Identify objects. ***PhotographInterpretation*** refers to act of studying a photograph in order to identfy objects and asses their significance and problems. ***Photogrametry*** is a science or an art of making a topographical map from air photograph. Or is the technique of using photographs to obtain measurments of the photograph.

Isocenter is the point on photo that falls on a line half-way between the principal and the nadri point. ***Mosaic*** refers to a collection of overlapping aerial photographs which have been matched to form one continuous representation of part the earth' surface. ***Photo mosaic*** is the picture that has been divided into (usually equal size) rectangular section, each of which is top replaced by another photograph that matches the large photo. Photo mosaic also refers to the compound by stitching together a series of sdjucent pictures of a scanning. Also it is an assembly of series of photographs into one continuous picture.

Principal point (PP) is the optical or geometric centre of photograph. It is the image of intersection between the projection optic axis that is perpendicular to the lens. Scale ratio increases at the same rate in all direction from the principal point. *Nadir* is the point vertically beneath the camera centre at the time of exposure.

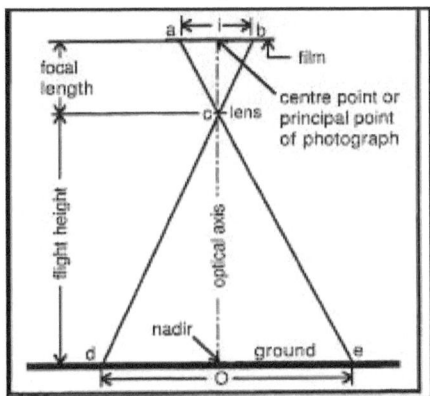

Camera station is the position of the camera situated or held. *Terreoscope* is the device by which two photographs as the same object taken at a slightly different angles are viewed together creating an impression of depth and solidity. Also can defined as the device fo viewing a stereoscopic pairs of separate images, depicting left eye, right eye are viewed of the same scene as the single three dimentional images. *Coverage* is the ground area represented on air photo.

Datum is a plane or line, which is a reference element. The plane determines the position of other elements. *Altitude* is the heght above datum, which is commonly the mean sea level. *Flyingheight* is the elevation of exposure station above the mean sea level (amsl) or the stated datum. *Flightline* is a line representing the track flown or to be flown by an aircraft. Flight lines concet the principal points of a series of airphotos.

Focal length is the perpendicular distance along the camera lens axis from its rear nodal point to the plan of the entire field used by the camera (film). *Resolution* is the ability of the camera in producing a sharply define image. *Strip* refer to the number of photographs taken along a flight path. *Tilt* is the angle between the optical axis of the camera and the vertical.

Stereo-photography 3-d visualisation

- Overlapping aerial photographs can be used to build 3-d stereoscopic visual models. These can be used to map out contours and heights of features

Photo 1

Photo 2

Plane travels at constant altitude above sea level. Height above ground varies with topography

overlap
60% of image

CHAPTER TWO

INTRODUCTION TO PHOTOGRAPH

Ways of Photograph Presentation

Photographs are presented in the following ways:
 (a) *Still Photographs:* Are photographs like those found on paper, prited on magazine, news paper or book. These ara photographs or pictures that does no move.
 (b) *Motional photographs*: Are objects paper or picture paper that are moving. These are found or shown on television, cinema and computer.

Recording and Interpreting Photographs

While information can be recorded in a writen formate, a particularly useful way of recording the information in a photograph is *sketching* it. When interpreting a photograph, anyone need to *infer* (use factual knowledge to decide what might be happening and the possible reasons for it. Some sample questions which learners should attempt to answer include:

- What is happenin in the photograph?
- What is the reason for this?
- What are the consequences of tis?
- What do the features tell us about the people or place?
- What is the most prominent part of the photo and why?
- How do these feature affect one another?
- Is it likely that this features has changed over time? Why or why not?

Uses of Photographs

Photographs have some of the following usese:
 (I) To describe an areas of diferent plces.
 (II) To provide geographical information
 (III) Used in showing traffic flowages Used in map making
 (IV) Used in mapmaking

(V) Used in research
(VI) Used in economic planning
(VII) Used in storing information
(VIII) Used in military purpose or operation
(IX) Used in meteorological prediction

Significance (Advantages) of Photographs

The same as uses; photographs have some of the followinf significances:
(i) Are non-selective, hence provide massive data and information
(ii) They show real picture or image of an object
(iii) They give quick information
(iv) Are used for map making in geographical studies.
(v) Importance for description of an area
(vi) They are cheap compared to other sources information. E.g. Map
(vii) They are used in geographical research.

Limitation of Photographs

Photographs have some of the following cons or disadvantages:
(i) They are non-selective; hence they give massive data which are sometimes not need or required.
(ii) They give wrong impression, because objects can be seen bigger than others which are not real due to various in pars of photography.
(iii) Not all objects can be clearly seen; some of them (objects) tend to decrease away from the camera position.
(iv) It is difficult to make measurement of distance or area (calculation) due to scale being not easily determined.

Photographs and Maps:

(1) *Similarities between photographs and maps.*
a. Both uses scale. They both show the relationship between maps and photo distance and actual distance.
b. Both show manmade and natural features of the earth's surface.
c. Both shows position or location of a particular place
d. Both are presented on a flat surface or materials

e. Both show features in three dimension
f. Both are produced by man's skills and technology
g. Both maps and photographs represents parts of the earth's surface
h. Both are used in military and engineering activities
i. Both of them store information for future memory and uses

(2) Contrast between Maps and Photographs:

	Photograph	Map
1	Non selective	Selective
2	Have a distorted scale	Have an accurate scale
3	Show true or real image	Use symbols and signs
4	Quickly produced	Take longtime to be produced
5	Used for map making	Not easy to be used for photo making
6	Less expensive in production	Very expensive in production
7	Do not need more knowledge	Need more knowledge
8	No North direction	Have North direction
9	Do not have a key	Have a key
10	Easy to be interpreted	Not easy to be interpreted

CHAPTER THREE

TYPES AND FEATURES OF PHOTOGRAPHS

Photographs can be classified according to the view point or position from which they were taken.

(i) Types according to the position of camera: There are four (4) types of photographs according to the position of camera in relation to the ground:
 a) Ground level (horizontal or terrestrial) photograph
 b) Aerial (air) photographs
 c) Oblique photographs
 d) Extra-terrestrial (Satellite) photographs

(ii) Types according to the major types: There are three (3) types of photographs according to the major types of photographs:
 a) Ground or horizontal photographs
 b) Oblique photographs
 c) Vertical aerial (air) photographs

(A) Ground or Horizontal Photographs

These are photographs that taken horizontal above the ground level. They are taken when the camera is at the same level as the object (s) being photographed. These pictures show very clearly what is immediately in front of the camera particular is not clearly seen. The hidden part of an object on the ground photograph is called *dead ground.* Ground photographs are usually the ordinary photographs.

Ground photograph is taken by camera when its optic axis is parallel or horizontal to the ground. There are two; Close up ground level photograph and General view ground level photograph:

(i) Close up Ground Level Photograph: Are photographs taken when the camera is focused on one major item or object. These major item or object obscure most of the other things behind it. The photographs when produced, they meet with obstacles which obscure the photographic view and produce dead ground. In these photographs, the focused objects is shown and seen clearly.

(ii) General View Ground Level Photograph: Are ground photograph that taken when there is no obstacles to obscure the photographic view. In these, objects become progressively smaller from foreground to the back ground. It gives general view of the scenery. The areas whose objects are obscured from the camera by those objects close to the camera are called *dead ground.* This photograph shows *Horizons. Pictures below shows ground photograph in which the camera was held horizontally.*

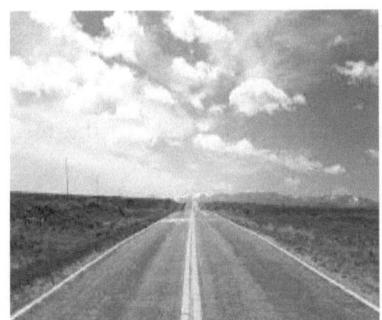

Parts of Ground Photographs

Ground photography has three parts: *Fore ground:* Represents the parts which are very near to the camera. In this part, the objects are very near and are usually large and cover small areas. *Middle ground:* This covers the ground which is at the middle position. The objects are slight large (medium size) and the area taken is relatively large. *Background:* This is the part of the photograph which covers the photographer. It covers a large area and shows small objects.

Characteristics of ground photographs:
(i) They are taken at the ground level.
(ii) The horizon is clearly seen (shown).
(iii) The shows one side view, especially front view.
(iv) Objects decrease in size when only become far from the camera.
(v) Shows items in small scale.
(vi) The objects in the fore ground and middle ground obscure those in the back ground.

Advantages of ground photographs:
(i) Objects are seen clearly on ground photographs (especially to the fore grounds).
(ii) It is easily to interpret ground photographs.
(iii) They are cheap in its production.
(iv) Are simple and common to be used.
(v) Are mostly used in storing information.
(vi) Are useful because they show the landscape in great detail.
(vii) They are also less expensive and easier to produce since does not require the use of any aircraft.

Disadvantages of ground photograph:
(i) They are not used in map making do to not having a uniform scale.
(ii) High scale distorted because does not show the whole area.
(iii) Not all objects are seen, this is due to the variation in size of objects from the camera hence it is difficult to identify and interpret features in the back ground as they are extremely small.

(iv) It is difficult to make ground measurement because the scale diminishes from the fore ground to the back ground.
(v) Tall tree, houses, hills and others near objects may obscure those further away.
(vi) They are not suitable for comparison since they do not provide a spatial distribution of natural and cultural features of a place.
(vii) They are not selective as the camera capture all objects of which are not required for analysis.

Steps for Interpreting Ground Level Photographs:

1. By describing the key features with reference to their location divide the photograph into three main areas i.e. fore ground, middle ground and back ground by considering left side, right side and central part of the photograph.

2. By describing, identify the key features and activities in the foreground, middle ground and back ground.

3. Make notes about the main natural and cultural features about where are they found, how many, how often and what is nearby.

4. With evidences, link the natural and cultural features to each other about how they do relate from each other.

5. Shows what information do the features on the photograph basing on the place and the people living there as well as the events happening there on the photographed area.

6. Suggest for and results or consequences for the features or events on the photographed area.

7. Suggest the reasons for the patterns and relationships shown and what is likely to happen in the future by give reasons to your answer.

8. Determine the time and weather conditions when the photograph was taken.

9. Describe the scale of the photograph and its impact on the features shown.

10. Draw a sketch of the photograph to illustrate the land use and activities taking place.

(B) Oblique Photographs

Oblique means sloping or slanting at an angle. By definition, oblique photograph is the types of photograph that taken by camera from an elevated angle less than 90°. The camera is tilted towards the objects or scenery. Normally oblique photographs they are taken from an angle of platform such as hill, elevated places, tower, and high buildings. Sometimes they can be taken by air craft at much high elevation.

Types of oblique photographs

There are two types of oblique photographs:
 (i) Ground oblique or Low oblique photographs
 (ii) Aerial or High oblique photographs

(i) Ground or low oblique photographs: Low oblique are taken when the photographer is standing on an elevated ground and hold the camera at an angle towards the lower ground. These photographs are taken from low height from the building, tower among others. They cover small area and they do not show horizontal. See the diagram and picture below:

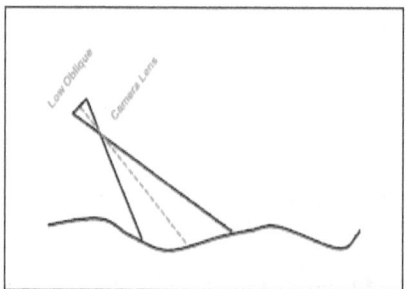 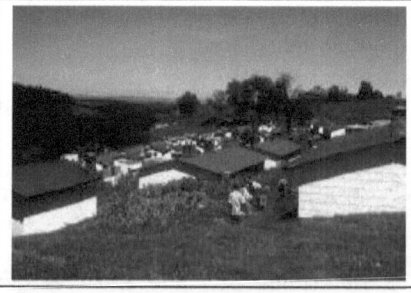

(ii) *Aerial or High Oblique Photographs:* Are photographs that taken from the sky with the camera tilted at an angle towards the ground.

They cover quite a large area and the photograph is similar in many ways to the ground oblique. They are normally taken by air craft.

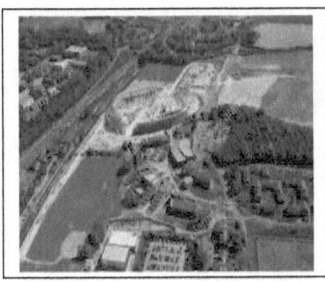 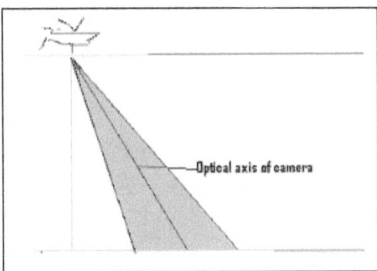

Characteristics of oblique photographs:

Oblique photographs have two major characteristics. Firstly, they show two side views of objects (i.e. front view and top view) and finally, oblique photographs are characterized by having two angles (i.e. low angle and high angle).

Advantages of oblique photographs:

a) Used as a substitute to other photographs. Ground can be substituted by low oblique, and vertical photograph is substituted by high oblique.
b) Show more than one side view (panoramic view of an area) unlike to vertical and ground photography.
c) Oblique photograph can be easily assessed and understood.
d) Do not require the air craft to fly directly overhead the area being photographed.
e) This is particularly useful in the case of photo-reconnaissance by the military.
f) The view of some objects is more familiar to the interpreter
g) Some objects are not visible on vertical photos, may be seen on oblique photo.
h) Cartographers tend to use them to construct physical and topographical maps.
i) They are also used to assess and determine the land use pattern of an area as well as rural and urban land planning.

Disadvantages of oblique photographs:

(a) A major disadvantage of an oblique photograph is that scale is inconsistent. This means that while distance can be calculated in the foreground, according to the provided scale, distance which is closer to the horizon would be completely inaccurate if calculated using the same scale.

(b) In both high and low oblique photographs, the scale diminishes from the foreground to the background.

(c) Like ground level photographs, the sizes of objects vary in size from fore ground to back ground.

(d) Tall objected features tend to obscure some important features in the middle and background.

Steps for Interpreting Oblique Photographs:

1. By describing the type of photograph, give the key features with reference to their location on the photographed area.

2. By describing, identify the key features and activities taking place on the oblique photograph.

3. Make notes about the main natural and cultural features about where are they found, how many, how often and what is nearby.

4. With evidences, link the natural and cultural features to each other about how they do relate from each other.

5. Show what information does the features on the photograph basing on the place and the people living there as well as the events happening there on the photographed area.

6. Suggest for and results or consequences for the features or events on the photographed area.

7. Suggest the reasons for the patterns and relationships shown and what is likely to happen in the future by give reasons to your answer.

8. Determine the time and weather conditions when the photograph was taken.

9. Describe the scale of the photograph and its impact on the features shown.

10. Draw a sketch of the photograph to illustrate the land use and activities taking place.

(C) Aerial or Vertical Photographs

Aerial photographs are the photographs which are taken from the high altitude or height when camera is situated on an air craft. Vertical photograph shows the plan of the scenery of features. Therefore, these are taken directly downwards or right overhead from the moving aircraft and also can be viewed by using stereoscope. Vertical aerial photograph its optical axis is perpendicular to the ground.

Types of aerial photographs:
(i) Terrestrial aerial photographs
(ii) Aerial photographs
(iii) Extra-terrestrial aerial photographs

(i) Terrestrial Aerial Photographs: These are taken with a camera in a fixed position near to the ground or on the ground.

(ii) Aerial Photographs: Are taken off by a precision camera mounted on an air bone platform e.g. Aircraft, balloon flying over a specific area.

(iii) Extra-Terrestrial Aerial Photographs: These are taken from very high altitudes by orbiting scale craft.

Characteristics of vertical aerial photographs:
(i) Taken by camera from the flying aircraft or satellite (synoptic view).
(ii) They show only upper view of an object.
(iii) Covers large or wide areas.
(iv) They are useful for map making.
(v) They have a uniform scale unlike to other types of photographs.

Advantages of vertical aerial photographs:
(i) Useful for map making.
(ii) Used for military activities.
(iii) Cover a large area.
(iv) Shows objects which are not displaced.
(v) Shows much information.
(vi) Their scales are essentially constant unlike to other photos.
(vii) Measurements are of directions are easier than oblique photographs. (Direction can be measured more accurately).
(viii) Vertical aerial photograph can be used a map (if grids and marginal data are added).

Disadvantages of vertical aerial photographs:
(i) Are costively in production and taking them
(ii) They involves time coming in taking and production
(iii) Are difficult to interpret features on them
(iv) They need and uses highly advanced technology both in making and production (*See the figures):*

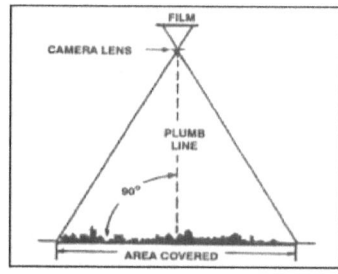
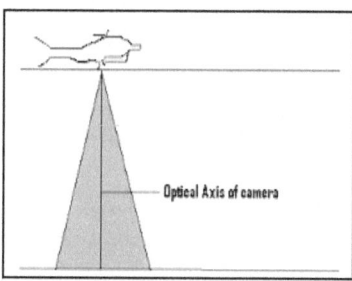

Differences between Vertical Aerial Photographs and Oblique Aerial Photographs:

Vertical Aerial Photograph	High or Aerial Oblique Photograph
(1) Cover a large area	Cover a small area
(2) Shows the top view of the	Shows the top and side view of the

objects	object
(3) Objects are less displaced	Objects are highly displaced
(4) Low scale distortion	High scale distortion
(5) Objects are small in size	Objects are large in size
(6) Used for map making	Not used for map making
(7) Difficult to interpret	Easily to interpret

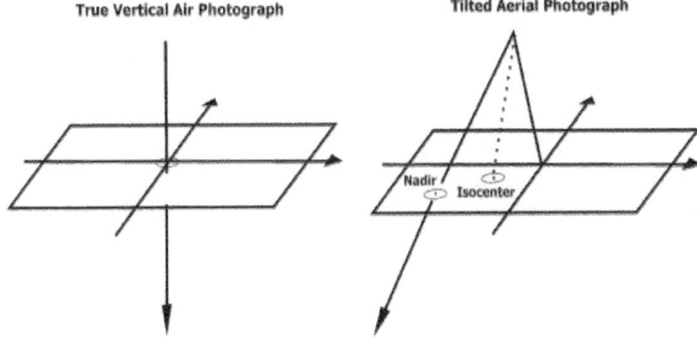

Differences between the Three Types of Photographs:

Na	Ground Photographs	Vertical Photographs	Oblique Photographs
1	Are taken when the camera is at the same level with the objects	Are taken from the air vertically above the object being photographed	Are taken from the ground with the camera tilted towards the ground.
2	Shows the front side of the object facing the camera	Show only the top side of the objects	Shows the top and side of the objects
3	Size of objects near the camera are larger than those further away	Objects in the centre are larger than those further away from the centre	Objects closer to the camera are larger than those further away.
4	Shows relatively small area	Shows relatively larger areas	Show relatively largest area

			possible.
5	Show close-up and general view objects	Show only general view of the objects	Show clearly objects near to the camera
6	General view photographs may show horizon	Do not include horizon	May show horizon
7	Show dead ground	May not show dead ground	May show dead ground
8	Taken at an angle of 90°	Taken at an angle of 180°	Taken at less 90° angle.

Marginal Data on Vertical Photograms

The marginal information or data of the photograph includes geographic location, time, date, project code, flight altitude, focal length, flight line number, company or institution, photo number and exposure.

Steps Used in Interpreting Vertical Aerial Photograph

The following are some of the procedures that can be used to make to interpret vertical aerial photograph:

1. Firstly, look the whole photograph over what is shows then describe your impression.

2. Through identification of important features in the photograph, use the clues created by shape, size, density, shadows, colour and patterns.

3. Show what information does the features on the photograph basing on the place and the people living there as well as the events happening there on the photographed area.

4. How do the natural features and cultural features relate to each other? Suggest for and results or consequences for the features or events on the photographed area.

5. Describe the kind of vegetation, water bodies and other associated features.

6. Suggest the reasons for the patterns and relationship shown and what is likely to happen in the future by give reasons to your answer.

7. Describe the scale of the photograph and its impact on the features shown.

Satellite or Extraterrestrial Photographs

Satellite or extraterrestrial photographs are images recorded electronically by the use of scanner and sensor placed in a satellite. Satellite photographs have the following types:

(a) *Land-sat satellite images:* Are images which send down the information about land use (land resources)

(b) *Mateo-sat satellite images:* These are image send information about meteorological data by daily weather forecasting.

Advantage (utilities or uses) of satellite photographs:
 (i) Used in weather prediction.
 (ii) Used in map making.
 (iii) Provide data about land use.
 (iv) Take very large image, hence they provide a lot of information.
 (v) Used in military purpose and operation.
 (vi) Store information for future uses

Disadvantages (drawbacks) of satellite photographs:
(i) They are Very expensive.
(ii) They show objects in very small size due to a large coverage.
(iii) Difficult to interpret them.
(iv) They need very high trained personnel.
(v) They are too very scientific hence uses high technology.

CHAPTER FOUR

PHOTOGRAPH READING AND INTERPRETATION

Time of Photograph Being Taken

Identification of time at which photographs taken, involves the following recognition that may give the specific time of when the photograph have been taken basing on the shadow of objects and human activities:

1. **At Morning time:** If the photographs taken during the morning time have the following evidences:
 a) A long lasting shadow (at west) of an object casting at west, it means the sun is at east (sunrise).
 b) Presence of agricultural activities like picking crops in farms.
 c) Position of the camera towards the sunrays, this is because the cameraman cannot stand against the sunrays so as to avoid the photograph to be affected by reflection of the sunrays.

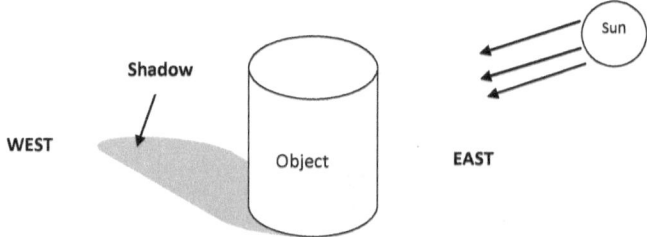

2. **At Evening time:** If the photograph is taken during the evening time, you have to look for the following evidences:
 a) Presence of long shadow that casting (lied) at east side; it means that, the sun is at west (sunset).
 b) The presence of agricultural activities like picking crops or harvesting.

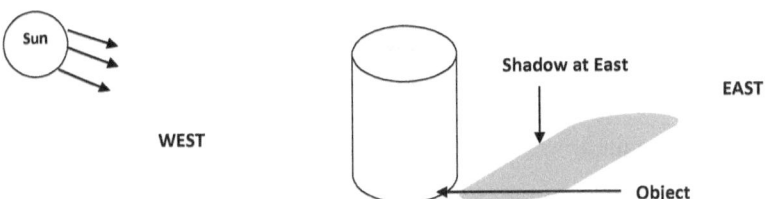

3. **During Afternoon time:** The presences of short shadow (around the object) at the centre of the object indicate the noon time. This is identified by the following evidences:
 a) Bright and clear image.
 b) Presence of drying activities.
 c) The shadow lies around the objects because the sun is overhead.

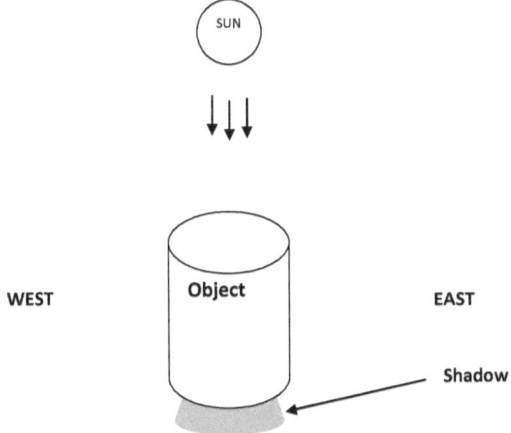

Seasons on Photographs

To identify in which season the photograph was taken involves the following evidences that shows season at which photograph was taken:

(i) Bright and clear sky with dry vegetation could indicate *Dry season*.

(ii) Luxuriate vegetation, young crops in the field, flowering plants and rain clouds in the sky could indicate *rain season*.

(iii) Presence of snow on the ground indicates *winter season*.

(iv) The *type of clothing worn* can also indicate the season or the time in which the photograph was taken; either cold or hot season.

(v) The *activities that appear on* the photograph predict the time of the season of the photograph; example agriculture, mining, fishing etc.

Parts of Photographs

There are three parts on photographs. These parts can be identified through knowing the position of the camera man. Photograph should be divided into three parts; both horizontal and vertical parts:

(i)Horizontal parts of photographs:
 (a) Fore ground
 (b) Middle ground
 (c) Back ground

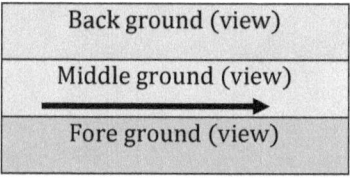

(ii) Vertical parts of photographs:
 (a) Left
 (b) Centre/middle
 (c) Right

LEFT	CENTRE ↓	RIGHT

Reading and Interpreting Photographs

Photograph interpretation involves the following:

(A) **Determining the Title:** The suitable title for a photograph can be determined or obtained by carefully studying the photograph. The information obtained in the photograph determines the choice of the title. Therefore, the information contained at the fore, middle and ground should be carefully studfied; such information combined with one's knowledge of geography.

(B) **Estimating the Time and Season:** In estimating the time and season, it is recommended to use the following:
- Shadow
- Vegetation
- Type of clothing
- Building style
- Activities on the field

(C) **Estimating Direction:** This is possible if time and place where the photograph was taken are known. Determined through:
 (a) Side of the shadow
 (b) Size of objects that differs from one ground to another.

(D) **Estimating the Size of Features:** It is not easy to measure and calculate the actual or ground distance from features as well as area. In estimating the size of features, it better to use comparison of different objects on the photography.

(E) **Identification and Interpretation of Physical Features:** The physical features on the photographs are:

(1) Relief
- *Flat landscape*
- *Hill area*
- *Mountainous areas*

(2) Drainage
- *River*
- *Lakes*
- *Drainage pattern*

(3) Vegetation
- *Natural vegetation*
- *Planted vegetation*

(4) Soil
- *Depend on the types of crops*
- *Depends on the nature of the land where the photo taken*

(5) Climate
- *Presence of cloud cover or not*
- *Types of clothing*
- *Type of crops*
- *Present or absent of Water or water bodies*

(F) **Identification and Interpretation of Human Activities:** Human activities on photographs are determined in relation to the presence of:
- *Pastoral farming*
- *Arable farming*
- *Forestry*
- *Settlement*
- *Wildlife conservation*
- *Mining and Industrial activities*
- *Transport and communication*

(G) **Farming or Agriculture:** Cultivation and livestock rearing as subsistence and commercial levels determined through the presence of the following on the photographs:
- *Subsistence crop farming*
- *Subsistence livestock farming*
- *Commercial livestock farming*
- *Commercial crop farming and Plantation farming*

Identification of Camera or Photographer's Position on Photographs

This refers to the direction or position of the camera or photographer. In studying photograph, the objects in the photograph their largeness or hugeness decrease towards far from the foreground.

The situation of identifying the position of the cameraman or camera mostly based on the decrease of size of the objects from fore to back ground. This tactic is suitable to the ground and oblique photographs. Therefore, the area or side showing big objects is the position of the cameraman or place where the photographer stood.

Example 1.

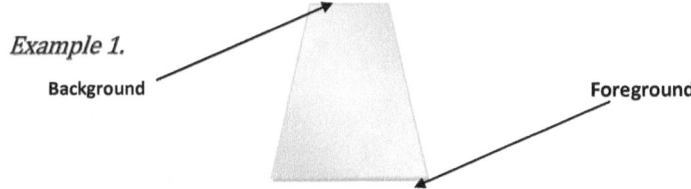

This photograph was taken from front side because the scale decreases from front view to the back view. Therefore, the camera man was at front side.

Example 2.

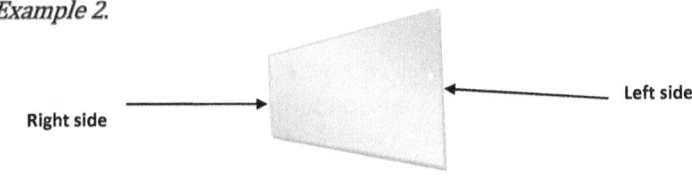

In this photograph, the direction of the camera set up left hand side and scale decrease towards the right hand side, so the photograph is taken from left side (left hand side). Therefore, the photographer was at the left hand side.

Example 3.

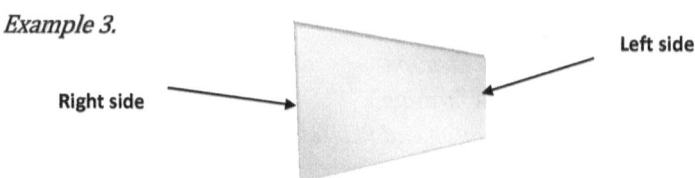

The direction of camera set up is in right hand side towards the left hand side, so the photograph was taken from right hand side. Therefore, the cameraman was at right hand side in his position.

Elements that are used in Identifying Features on a Photograph

The followings are elements (principles) that used in identifying features on a photograph:

(1) Shapes: Represent all features that have linear shapes like road, river railways.

(2) Tone or colour: Involves Colour of the objects that determined by the reflection ability of the object.

(3) Texture: Identified by roughness (e.g. forests) smoothness (e.g. water bodies) and intermittent (e.g. grass land)

(4) Pattern: Refers to the arrangement of features within an area of photograph e.g. manmade vegetation versus natural vegetation.

(5) Site and Association: Site concerns with where something commonly is found (e.g. coffee at Bukoba, gold mineral at Geita and tea at Arusha in Tanzania).

(6) Others are size of the object, shadow and height and depth (elevation).

Factors Affecting the Clarity of the Photographs

Distortion of the quality of photographs is influenced by the camera itself, environment, shutter and technology of production and nature of the objects taken by a camera. The following are some of the reasons and factors that may cause lowering the quality of photographs (photos):

Nature and colour of the object: Colour of an object may affect the quality of image taken. The object that is black in colour may lead to the dark image, while whitish object may also cause for the image that affect by light reflected from the object.

Climatic conditions: Climatic condition where the image of an object is taken may influence the quality of the image positively or negatively. Winter season with lot of clouds cover may cause dark image of an object while summer season having strong sunshine may cause whitish image of an object.

Knowledge and experience of the shutter: Experience and knowledge of the person taking the image by using camera is an important thing in causing a better product of the image taken. The cameraperson is the one in which influences the good and bad appearance of the photo. There some qualities of the photo taken can be reduced or improved basing on the knowledge and experience of the shutter.

Distance between the camera and the object: Sometimes the distance is the key problem to the quality of the image depending with the quality and modern of the camera. Long distance between the object and the shutter may affect the quality of the photo being produced. Camera having Low power and low quality have low ability to zoom distant objects, hence may led to the low quality of the image that will be produced.

Sharpness: Sharpness determines the amount of detail an image can convey. System sharpness is affected by the lens (design and manufacturing quality,

focal length, aperture, and distance from the image center) and sensor (pixel count and anti-aliasing filter). In the field, sharpness is affected by camera shake (a good tripod can be helpful), focus accuracy, and atmospheric disturbances (thermal effects and aerosols).

Lost sharpness can be restored by sharpening, but sharpening has limits. Over sharpening, can degrade image quality by causing "halos" to appear near contrast boundaries. Images from many compact digital cameras are sometimes over sharpened to compensate for lower image quality. Image processing, lens, user errors and other factors take away some sharpness and this can be compensated by sharpening either in camera or in photo editor.

Noise: Is a random variation of image density, visible as grain in film and pixel level variations in digital images. It arises from the effects of basic physics— the photon nature of light and the thermal energy of heat— inside image sensors. Typical noise reduction (NR) software reduces the visibility of noise by smoothing the image, excluding areas near contrast boundaries. This technique works well, but it can obscure fine, low contrast detail.

Dynamic range: (or exposure range) is the range of light levels a camera can capture, usually measured in f-stops, EV (exposure value), or zones (all factors of two in exposure). It is closely related to noise: high noise implies low dynamic range.

Tone reproduction: Is the relationship between scene *luminance* and the reproduced image brightness. Failure to consider this, it can lead to the distortion of image quality of an object taken by a camera.

Contrast: also known as *gamma,* is the slope of the tone reproduction curve in a log-log space. High contrast usually involves loss of dynamic range — loss of detail, or clipping, in highlights or shadows.

Color accuracy: Is an important but ambiguous image quality factor. Many viewers prefer enhanced color saturation; the most accurate color isn't necessarily the most pleasing. Nevertheless it is important to measure a

camera's color response: its color shifts, saturation, and the effectiveness of its white balance algorithms.

Light falloff: Darkens images near the corners. It can be significant with wide angle lenses. This distortion may be caused due to the poor knowledge of the shutter light falloff.

Lateral chromatic aberration (LCA): also called "color fringing", including purple fringing, is a lens aberration that causes colors to focus at different distances from the image center. It is most visible near corners of images. LCA is worst with asymmetrical lenses, including ultrawides, true telephotos and zooms. It is strongly affected by demosaicing.

Lens flare: Including "veiling glare" is stray light in lenses and optical systems caused by reflections between lens elements and the inside barrel of the lens. It can cause image fogging (loss of shadow detail and color) as well as "ghost" images that can occur in the presence of bright light sources in or near the field of view.

Color moiré: Is artificial color banding that can appear in images with repetitive patterns of high spatial frequencies, like fabrics or picket fences. It is affected by lens sharpness, the anti-aliasing (low-pass) filter (which softens the image), and *demosaicing* software. It tends to be worst with the sharpest lenses.

Artifacts: Software (especially operations performed during RAW conversion) can cause significant visual artifacts, including data compression and transmission losses (e.g. Low quality JPEG), over sharpening "halos" and loss of fine, low-contrast detail.

Shutter speed: Rule of thumb for 35mm film or FF digital is 1/focal length. That means, for a 50mm focal length set on your lens use 1/50s or shorter. This is just a starting point and smaller format cameras (APS etc.) will need shorter. You can compensate with image stabilizer (allows 1x - 4x longer shutter speeds for stationary subjects - IS does not help with moving stuff,

only with shaking photographers), or a tripod. With tripod, avoid so called critical shutter speeds.

These are speeds usually around 1/10 sec where the tripod doesn't work as well as at shorter and longer exposure times. If you have a DSLR, you can also make your camera steadier if you engage the *mirror lockup* feature. This prevents mirror slap. When shooting fast movement (e.g. sports), you may need shutter speeds as short as 1/500s or more. A flash can help.

Aperture: Lenses are usually best when stopped down a little. Wide open lenses are often less sharp, especially towards borders of the frame. Lenses also become less sharp when extremely stopped down (f/16 or more) due to diffraction. Wide open lenses have smaller depth of field and small focusing errors may be visible more than when stopped down.

Camera (image file) resolution: You need to start with high enough resolution. Sometimes people resize the image by mistake to a small size, say 640x400 and then use them for printing or for large images on the web. But the image information is already gone and the images look blurry. High resolution is especially needed for printing. You will need around 300 pixels for every inch of width. So for printing a 10x15" you need 3000x4500 pixels.

JPEG compression: Images that are too compressed may look blurry.

Any glass layers: In front of the lens (like low quality filters) may add a little bit of blur.

Lens quality: Sometimes the low quality of the lens may influence the distortion of the photo taken by a camera having a low quality lens.

Focusing errors: The AF may be front or back-focusing. This can be compensated through the camera menu or by professional service. Look up "focus and recompose" on the internet for an explanation of the technique whereby photographers use the center focusing point, and then recompose causing focusing errors. With fast lenses with very shallow depth of field there may be slight movement of the photographer or the subject between

achieving focus and taking the picture. It can be big enough to make the image out of focus.

If you suspect that this is a problem, consider using servo focusing (sport) mode that does not stop focusing after half pressing the shutter button.

Parts of the camera

The following are the basic parts of camera as labeled to the camera:

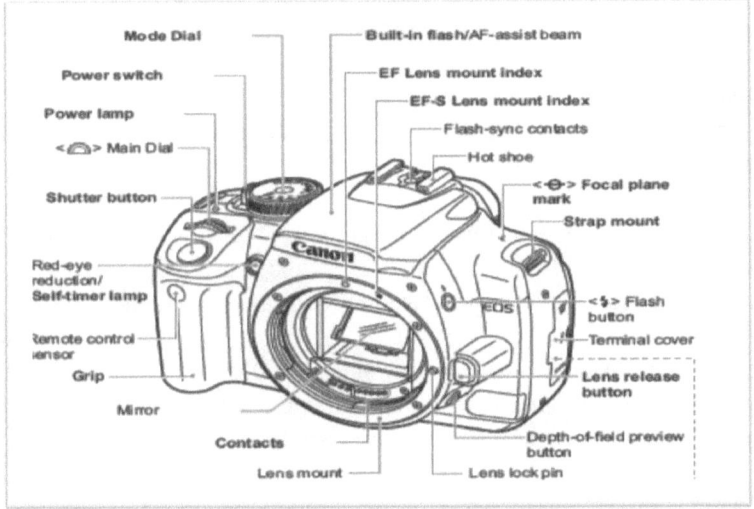

CHAPTER FIVE

IN-DEPTH STUDY OF AERIAL PHOTOGRAPH

Aerial photograph is any photography taken from the air. Normally it is taken vertically from the aircraft using a highly accurate camera. There are several things can be looked for to determine what makes one photograph different from another of the same area, including type of film, scale and overlap. Other important terms used in aerial photograph are stereoscopic coverage, fiducial marks, focal length, roll and frame numbers:

1. Film: Most of air photo mission are flown using black and white film, however colour, infrared, and false-colour infrared film are sometimes used for special project.

2. Focal length: The distance from the middle of the camera lens to the focal plane i.e. the film. As focal length increases, image distortion decreases. The focal length is precisely measure when the camera is calibrated.

3. Scale: The ratio of the distance between two points on photo to the actual distance between the same two points on the ground. If a 1km stretch of highway covers 5cm on air photo, the scale is calculated as follows:

$\frac{\text{Photo distance}}{\text{Ground distance}} = \frac{5cm}{1km} =$ 1:20 000 i.e. 1mm on photo = 20 000mm on the ground.

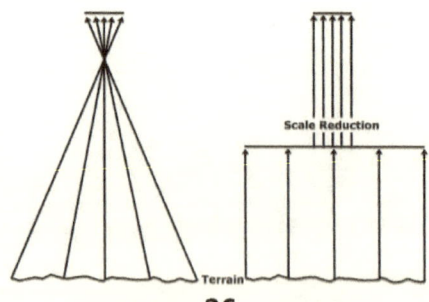

Another method used to determine the scale of photo is to find the ratio between the camera's focal length and the plane's altitude above the ground being photographed. If a camera's focal length is 152mm, and the plane's altitude above ground level (AGL) is 7600m, using the same equation as above the scale would be 1:50 000 (i.e. 1mm of photo represents 50 000mm of the ground).

Scale may be expressed in three ways: *Unity equivalent, Representative fraction* and *Ratio*. A photographic scale of 1millimitre on the photograph represents 25 meters on the ground would be expressed as follows:

- Unity equivalent: 1mm = 25m
- Representative fraction: $1/2500$
- Ratio: 1:25 000

Two terms that are normally mentioned when discussing scale are *large scale* and *small scale*. Large photo (e.g. 1:25 000) cover a small area in greater detail. A large scale photo simply means that ground features are at a larger, more detailed size. The area of ground covered that is seen on the photo is less than at smaller scale. Small scale photo (e.g. 1:50 000) cover large areas in less detailed. A small scale photo. Simply means that ground features are at a smaller, less detailed size. The area of ground coverage that is seen on the photos is greater than larger scales.

4. *Fiducial marks*: Small registration marks exposed on the edges of a photograph. The distances between fiducial marks are measured when a camera is calibrated, and this information is used by cartographer when compiling a topographic map.

5. *Overlap:* Is the amount by which one photograph includes the area covered by another photograph, and is expressed as a percentage. The photo survey is designed to acquire 60 percent forward overlap (between photos along the

same flight line) and 30 percent lateral overlap (between photos and adjacent flight line).

6. *Stereoscopic coverage:* The three dimensional view which results when two overlapping photos (called stereo pair), are viewed using stereoscope. Each photograph of the stereo pair provides a slightly different view of the same area, which the brain combines and interprets as a 3-D view.

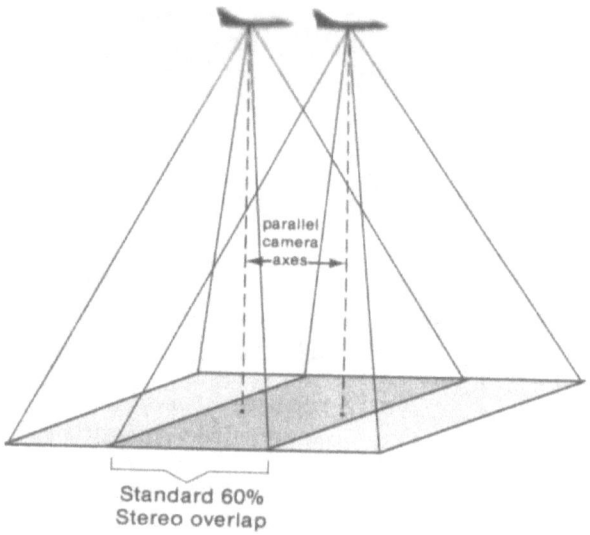

Standard 60% Stereo overlap

7. *Roll and Photo numbers:* Each aerial photo is assigned a unique index number according the photo's roll and frame. For example, photo B 29809-30 is the 30th annoted photo on roll B 29809. This identifying number allows you to find the photo in any photo archive, along with metadata information such as the date it was taken, the planes altitude, the focal length of the camera the weather condition.

8. *Flight line and index maps:* At end of the photo mission, the aerial survey contractor plots the location of the first, last and every fifth photo centre,

along with its roll and frame number, on a topographic map. Photo centres are represented by small circles, and straight lines are drawn connecting the circles to show photo on the same flight line.

This geographical representation is called an *air photo index map*, and it allows someone to relate the photos to their geographical location. Small scale photographs can be indexed on 1:250 000 topographic maps and lager scale photographs are indexed on 1:50 000 topographical maps.

9. *Orthophotography:* Orthophotographic projections depict things in their true plan position. In the production of orthophotography, the original photographs are employed to create a stereo-model which is scanned, by very expensive equipment called ***orthophotoscope***, in very small segments; displacement are corrected and the resulting trips are merged to create a ***photo-map***. On an orthophoto distances, areas and direction can all be accurately measured easily. The orthophoto maps show more details than the older cartographic product due to the actual image background.

 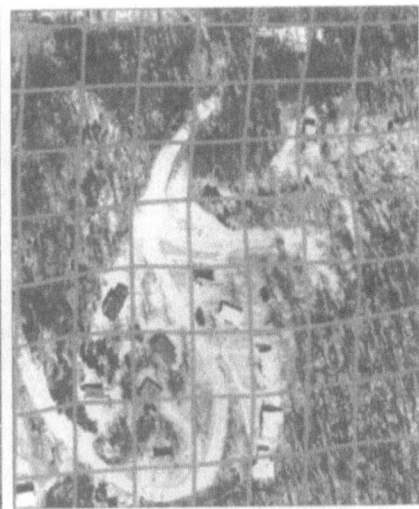

10. Over flight Characteristics: Aerial photographs are generally taken in a North-South or East-West direction along parallel flight lines. *Flight lines* are the paths that an aircraft takes in order to ensure complete coverage of the area to be photographed. Flight lines are arranged to give a succession of overlapping photos. The photos overlap between within and between flight lines, and the overlap in these two directions is called *forward overlap* or *end lap* and *side lap*.

Forward overlap within a flight line is from 60 to 70%. This provides for stereoscopic view of the area and complete coverage. *Side lap* between flight lines is from 25-40% and ensure that no areas are left unphotographed.

11. Coverage errors: These are two main causes of unsatisfactory ground coverage (which are drift and crab). *Drift* is the lateral shift of the aircraft from the flight line. This may be caused by pilot error or the effect of wind on the aircraft. *Crab* occurs when the aircraft is not oriented with the flight line. In this, photo edges are not parallel to the flight line and it is usually occurs when the pilot is trying to compensate for a cross wind and orients the plane into the wind to maintain the flight line.

Topographic or Height Displacement

By definition, *displacement* is the radial distance between where an object appears in an image to where it actually should be according to a planimetric coordinate system. The word radial means *spreading out from a central point*.

Relief displacement is caused by changes in the distance between the ground and the camera as the plan flies over the ground. Relief displacement is:

- Radically outward for features above the nadir elevation.
- Radically inward for features below the nadir elevation.

The reason for small relief displacement from space is that to achieve a given scale a shorter focal length lens requires flying at a lower altitude. The effect of using short focal length lens is to increase topographic displacement, distortion and the apparent depth of the third dimension (vertical

exaggeration in stereoscopic images). To get a scale of 1:20, 000 you fly at 10, 000ft with a six inch focal length lens; but at 20, 000ft with a 12 inch focal length lens.

Basically, the most important cause of object displacement on aerial photograph is local relief. Remember, that there are time when increased displacement can be a good thing (e.g. for height measurements). SO is flat areas you may want to use a short focal length lens to achieve a given scale. From space then someone can still extremely long lens with little displacement. The formula for topographic displacement on a single photo is:

$$d = \frac{r(h)}{H} = \frac{r(h)}{(A-E)}$$

$$h = \frac{d(H)}{r} = \frac{d(A-E)}{r}$$

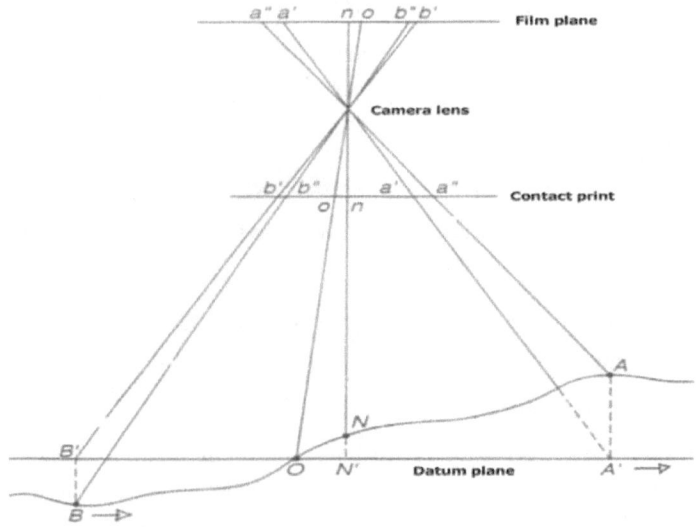

Where:
- d = Radical displacement (with respect to the nadir) and the photo at the same scale as the nadir.
- r = Radical photo displacement from nadir (PP) to the point of displacement (usually the top of the object).
- h = Height of the object or difference in elevation (E) between nadir and displacement point.

A close look at the equation involved in the calculations of the equations of the relief displacement shows that some important general relationships are involved. These relationships can be stated as follows:

1. There is no topographic displacement at nadir. If *r* is zero, then *so* is *d*.
2. Assuming datum elevation to be at nadir, points above the datum are displaced radically away from nadir while points below datum are displaced radically towards nadir (relief displacement).
3. Topographic displacement varies directly with the radical distance from the nadir to the object. A particular elevation two inches from the nadir will have half the displacement as that same elevation four inches from the nadir (overlap).
4. Topographic displacement varies directly with the height of an object. A 100ft tree would be displacement twice as far as a 50ft tree the same distance from nadir.
5. Topographic displacement varies inversely with the flying height of the base of the object. As a result there is little apparent topographic displacement on space photograph.

The Geometry Vertical Aerial Photographs

The scale of vertical aerial photograph is a function of the cameras' focal length (f) and the altitude or height from which the exposure is made (h). The vertical air photo presents a true record of angles, however the horizontal

distance are subject to wide variation due to changes in topography or flight height. The normal scale is representative only of the datum, an imaginary, horizontal plane passing through a specified elevation above mean sea level (a.m.s.l).

In computing an accurate photographic scale, one has to know that, focal lengths of aerial cameras vary according to specific needs and purposes. Focal lengths wide used are 88mm ($3°5''$), 152mm ($6°$), 209mm ($8°25''$) or 340mm ($12°$). The most common used focal lengths are 15mm and 88mm. If someone knows the focal length used and the altitude of the aircraft, it is possible to determine the scale of the air photo using the relationship between map scales. As we have seen earlier, there are three types of scale on aerial photographs:

1st Equivalent (statement) scale: One millimeter represent one kilometer on ground.

2nd Representative Fraction (RF): Ratio on photo with ratio on ground.

$$RF = \frac{numerator}{denominator} = \frac{unit\ on\ photo}{unit\ on\ ground} = \frac{1}{30\ 000} = 1:30\ 000$$

3rd Photo Scale Reciprocal (PSR): Is the opposite of Representative of Fraction.

$$\frac{denominator}{numerator} = \frac{unit\ on\ ground}{unit\ on\ photo} = \frac{30\ 000}{1}$$

Methods of Measuring Scales on Aerial Photographs

There are three methods of measuring scale on aerial photographs: The use of centre of photograph method, intersection point method and geometric method.

(i) *Centre of photograph method:* This method use the centre of photograph comparing with the size of object on the ground.

From the figure above, assume that 4cm on the photo represent 100m on the ground, hence the RF is calculated as follow:

4cm = 100m
1cm = ?

$$\frac{4xcm}{4cm} = \frac{100m}{4cm} = \frac{10\,000cm}{4cm} = 2500$$

Therefore RF = 1:2500

PSR = 2500

(ii) Intersection point method: Check the following worked example:

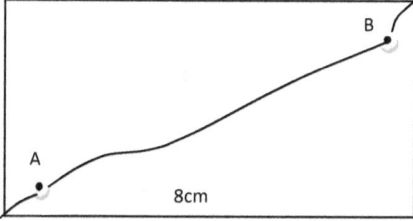

8cm on Photo = 100,000 the grond

$$\frac{8cm}{8cm} = \frac{100,000cm}{8cm} = 12,500$$

Therefore, the scale of Photo is 1: 12 500.

(iii) **Geometric Method:** This method involves derived formula or equation from angles drawn in relation between camera distance and ground distance as well as height respectively.

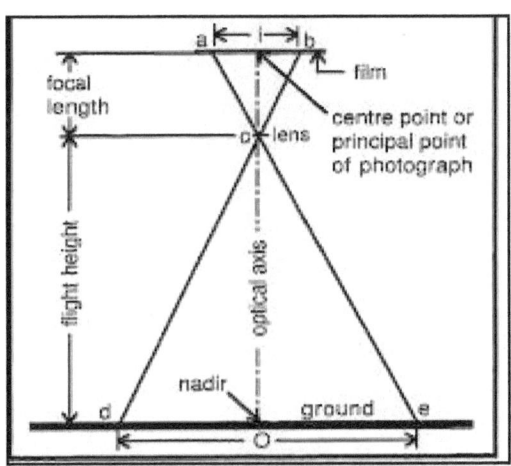

Through the figure above:

Let; ab//de

<acb = <dce or <abc = <dec (both external and internal angles)

△ abc ≈ △ ced

$$\frac{ab}{de} = \frac{Photo\ distance}{Ground\ distance} = \frac{PD}{PG} \quad OR = \frac{Focal\ length}{Height} = \frac{F}{H} =$$

Given that F=152.17cm, H=25,000FT 6inches. In finding the solution, all data shoulbe into the same units:

1inch = 2.54cm
12inch = 1foot
1foot = (2.54 x 12)cm

1ft = 30.48cm

$$\text{Therefore; } \frac{F}{H} = \frac{152.17 CM}{25000f + 6 inches} = \frac{152.17 cm}{25000 \times 30.48cm + 15.24cm}$$

$$R.F = \frac{1}{50,076,574} \approx \frac{1}{50,000}$$

In case when aircraft change the height of elevation, the following formula provides a more accurate scale:

$$PS = \frac{f}{H - h}$$

Where: PS = photo scale, f = focal length, H = height of aircraft above mean sea leve and h = heigh of the groung surface.

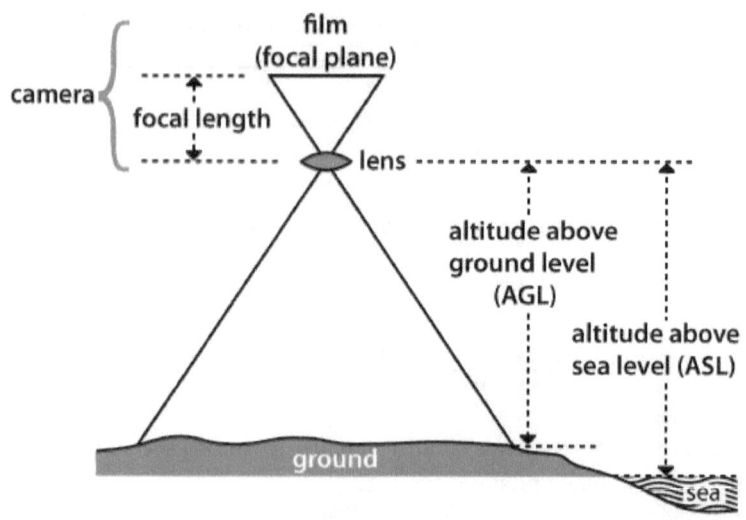

Sometime it happen that, a particular air photo that the aircraft's flight altitudes is unknown or not given. For this case the scale can be found based on the same idea of average scale as shown below:

$$PS = \frac{PD}{MD} \times MS$$

Whereby: PS = photo scale
PD = distance between two known points on the air photo
MD = corresponding distance on the map
MS = map scale

An example: given that, DP = 20mm, DM = 50mm, MS = 1:20,000. Find the photo scale.

$$\text{Therefore; } PS = \frac{20}{50} \times \frac{1}{20,000} = \frac{1}{50,000} \text{ Or } 1:50,000$$

Photograph Distortion and Displacement

Both distortion and displacement cause changes in the apparent location of objects in photos. The distinction between the types of effects caused lies in the nature of the changes in the photos. There are basically four (4) types of distortion and three types of displacement:

Types of distortion are:
1) Film and print shrinkage
2) Atmospheric refraction of light rays
3) Image motion
4) Lens distortion

Types of displacement are:
1) Curvature of the earth
2) Tilt
3) Relief or topography

Distortion shift in the location of an object that changes the perspective characteristics of the photo. Displacement shift in the location of an object in a photo that does not change the perspective characteristics of the photo (the fundamental displacement between an object's image and its true plan position which is caused by change in elevation. Displacement and distortion cause for the following problems:

1. Lens distortion,

2. Tilt displacement and

3. Topographic displacement.

Causes of Distortion and Displacement

In general, distortion and displacement are caused by the following factors:
- a) Topography or relief of an area.
- b) Tilt of the plane.
- c) Curvature of the earth.
- d) Atmospheric refraction of light rays.
- e) Image motion due to the movement of the camera.
- f) The optical or photographic deficiencies. This is due to the film and paper shrinkage, lens aberrations, filter aberrations, failure of the film-flattening mechanism in the camera focal plane, and shutter malfunction.

CHAPTER SIX

SCALES AND AREA MEASUREMENT IN AIR PHOTOGRAPHS

Scale is the ratio of distance on an aerial photograph to that same distance on the ground in the real world. It can be expressed in unit equivalents like 1inch = 1, 000 feet (or 12, 000 inches) or as dimensionless representative fraction (1/12, 000) or as dimensionless ratio (1:12, 000).

In the following diagram illustrates some important concepts about the geometry of the flat surface that apply to the calculation of scale and areas from air photos. The first thing to notice is that, the distance from 'D' to 'E' and 'A' to 'B' are proportional to the ratio of local length (f) to the length above the ground (H). This allows for the calculation of proportional lengths because the angles formed on either side of the lens, labeled point 'C' on the diagram, are identical. Also get noted that, the Centre point of the ground (nadir) fall along the optical axis of the camera in this idealized diagram

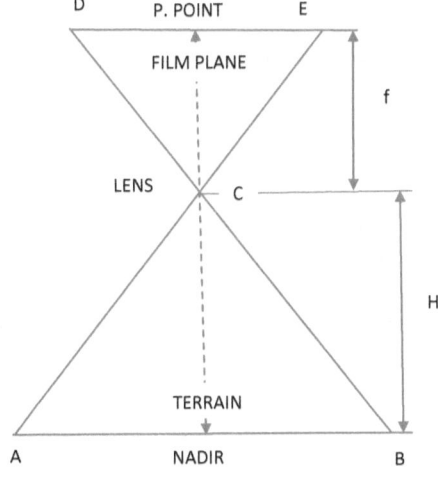

From the diagram, note the following:

<ACB = <DCE

$$\frac{f \, (focal \, length)}{H \, (altitude)}$$

Knowledge of the camera focal length and the air craft altitude makes it possible to determine photo scale (PS) and the representative fraction (RF) of a photo. The photo scale and representative fraction may be calculated as follows:

$$PS = \frac{f}{H}$$

Where: PS = Photo Scale

H = Altitude

f = camera focal length

$$FR = \frac{1}{(H/f)}$$ Where: RF = Representative fraction

f = Camera focal length

H = Altitude above the ground

> RF = 1 divided by ratio of altitude (H) and camera focal length (f)

The method of deriving photo scale is theoretically sound; it often happens that either camera focal length or altitudes above the ground are unknown. In such cases, scales may be determined by the ratio of the photo distances between two points to map distance (MD) using map scale (MS) or ground distance (GD) between the two points.

$$PS = \frac{PD}{GD}$$

Variables:

$$PS = Photo\ Scale$$
$$PD = Photo\ Distance$$
$$GD = Ground\ Distance$$

Ground distance and map distance are used to differentiate a measurement from the map sources and the real world distance that calculated from map scale, measures using the map's scale bar or measuring by using a tape in the field.

When calculating the scale, photo distance and ground distance must be in the same units so as to yield a unitless RF; the map scale reciprocal (MSR) and the photo scale reciprocal (PSR) are both unitless.

$$RF = \frac{1}{[(MD * MSR)/(PD)]} \quad OR \quad \frac{1}{[(CPD * PSR)/(MD)]}$$

Where variables are: **MD** = Map Distance

MSR = Map Scale Reciprocal

PSR = Photo Scale Reciprocal

PD = Photo Distance

Ground distance can be measured with surveying equipment, it can be calculated by multiplying the measured distance on a map by the map scale, or it can be approximated using the map's scale bar. If the path or road segments, and then straighten it out and measure how long it is.

Expressing and conversion of scale

As have been shown earlier, expressing of photo scales are into the following:
1) *Scale ratio*
2) *Representative Fraction (this combined to the ratio scale)*
3) *Equivalent scale*

4) *Graphic scale. Also called a bar scale, used on maps and drawings to represent length scale on paper with length unit.*

In conversion of photo scales, the process should have to involve transformation of common units like:

a) 1 meter = 100 centimeters = 1,000 millimeters
b) 1 foot = 12 inches
c) 1 yard = 3 feet
d) 1 meter = 3.28 feet
e) 1 square meter = 10.76 square feet
f) 1 acre = 43,560 square feet
g) 1 square kilometer = 230.4 acres

If one inch on the photo is equivalent to 1,000 feet on the ground (or 12,000 inches); RF 1/12,000, PS = 1: 12,000; PSR = 12,000. The 12,000 part is important, that is because the real world distance per unit distance on the photo, it does not have to be inches, it can be millimeters or centimeters or whatever.

The important thing to remember is that both terms are inches, or whatever unit you choose, so the resulting fraction is unitless.

Photo's areas Measurements

Once anyone mastered to measure distances, have to know that, areas have squared units. Knowing distance will help to learn how to arrange the calculations and to recognize incorrect calculations.

The precious of measurement it dependent upon the ability to determine photo scale, the precision of the conversion factors, the precision of the measuring device (like using a standard 12 inches ruler or millimeter scale ruler) and the accuracy with which you can determine the edges of a feature or area.

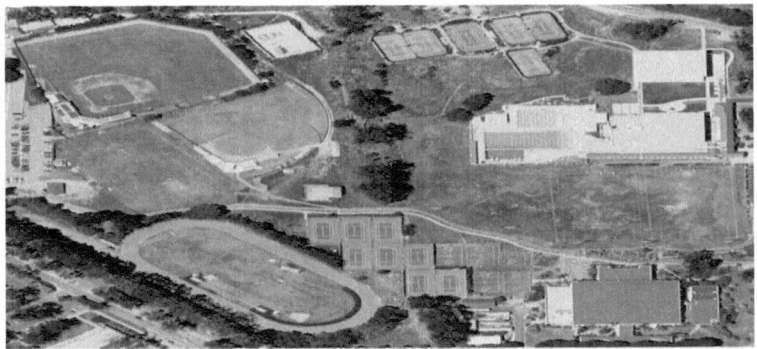

In measuring areas from photos it is not a simple task, involves some techniques. Therefore, the techniques deployed in measuring areas from air photos are: *Polar planimeters method, Transect, Dot grids method, Grid square method, Polygon method, Stereoploters* and *GIS method.* All of these methods of area measurements, some of them will be explained in detail.

1. **Polar Planimeters:** Planimeter is a mechanical instrument used to compute the area of a planar region. Linear planimeter and polar planimeter have the same function. The planimeter is used by moving the tracer point around the boundary of the region being measured.

2. **Transect:** transect or linear intercept method of canopy estimation is analogous to the dot grid method and is similarly accurate. In this method line are superimposed on the aerial image and the length of each line that overlays tree canopy is compared to the total line length. Canopy cover is then calculated as: %canopy cover = 1000 x (length of lines covered by tree/total length of lines in sample).

Lines may be printed on a transparent sheet or can be designed by randomly dropping a clear scale on the photo. Accuracy is improved by using more short lines rather than a few long lines.

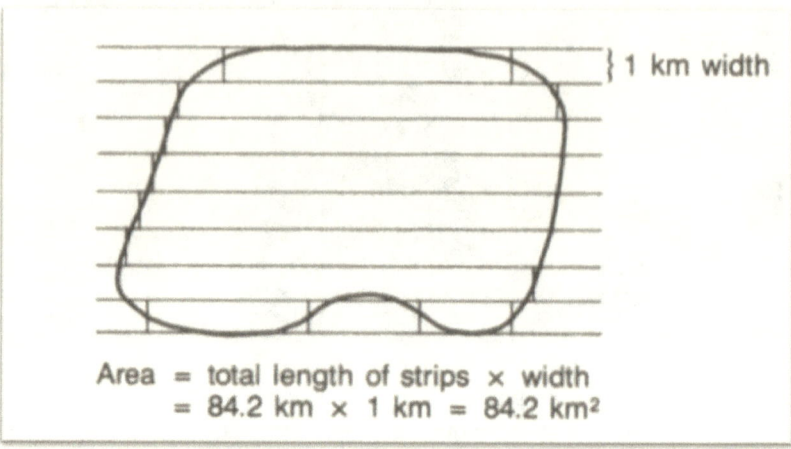

Area = total length of strips × width
= 84.2 km × 1 km = 84.2 km²

3. ***Dot Grids:*** Dot grids are estimations involved laying a transparent grid over an area of interest and counting the grid cells or dots that fall within that area. Each dot or grid cell is proportional to an area according to the scale of the source image, summing the number of dots or grid cells and multiplying by the scale conversion allowing estimating areas quickly.

A dot grid is a sheet of transparent material imprinted with dots arranged in regular grid. Dot grids can be purchased from forestry suppliers or developed with graphics software and printed onto transparency material.

The canopy cover estimate is made by laying the dot grid over the area of the aerial photo to be sampled and counting the number of dots that fall on tree crowns. Percent crown cover can then be calculated as: %canopy cover = 100 x (dots falling on trees/total number of dots within sample area).

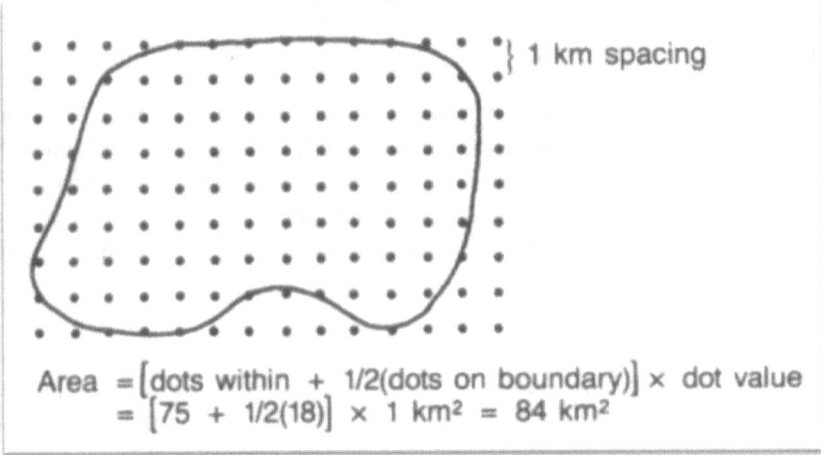

Area = [dots within + 1/2(dots on boundary)] × dot value
= [75 + 1/2(18)] × 1 km² = 84 km²

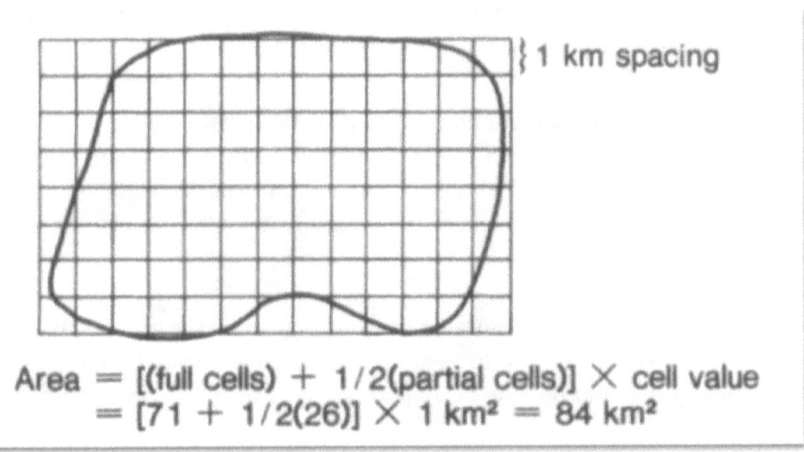

Area = [(full cells) + 1/2(partial cells)] × cell value
= [71 + 1/2(26)] × 1 km² = 84 km²

4. *Stereo-plotters and GIS:* These methods can be used when interpreting air photos because sometimes relative size, and differences in areas, can lend support to an interpretation. When exacting measurements are required, however dots grids and scaled measurements need an additional level of correction. The device for performing this correction area called

stereoplotters. There are two types, analog and digital: *Analog stereoplotters* and *analytical stereoplotter.*

Analog stereoplotters require specialized knowledge and calibration but yield extremely accurate measurements when correctly in conjunction with enough geometric control. The second type of device is called an *analytical stereoplotter* and is digital. The main benefit of these two devices is that they are usable by trained individuals and are very reliable when maintained properly.

Geographic Information System (GIS) as well as most image processing software packages have image registration capabilities that have replaced manual area estimation techniques. But not in all cases is GIS feasible or practical, and if someone lacks sufficient ground control points in order to georectfy the imagery the additional cost of doing so may not afford enough accuracy so as to be cost effective.

Methods of Determining Scale of Vertical Photograph

There are two types of scale of aerial photograph, which are *point scale* and *average scale.* *Point scale* is the scale at a point with a specific elevation on the ground (i.e. every point on a vertical photograph at a different elevation will have a different scale).

Average scale is the scale that specific to a single point on the ground. Average scale may be determined for the entire project area, a set of photographs, single photograph, and portion of a photograph or between two points on a photograph.

Therefore, determining scale of photograph involves mathematical calculation. There are various methods that can be used to determine the scale of vertical aerial photograph depending on the nature and types of information available.

1. The scale from photo and ground measurement

There are various methods (are) used to determine the scale of a photograph, depending on the types of information available. The basic and most straightforward technique of expressing scale is the one that uses the ratio of the distance between two points on the photograph (PD) to the distance between the same two points on the ground (GD), from the basic geometry of vertical aerial photograph.

$$PS = \frac{PD}{GD}$$

Therefore similarly, map scale can be expressed as:

$$MS = \frac{MD}{GD}$$

Where: *PS* is the Photo scale, *MS* is map scale, *PD* is the photo distance measured between two well identified points on the photograph *MD* is the map distance measured between two points on the and *GD* is the ground distance between the same two points on the photograph (or on the map) expressed in the same units.

As explained earlier, the photo scale reciprocal (PSR), sometimes called photo scale factor or the map scale reciprocal (MSR), sometimes called map scale factors is simply the inverse of the photo scale or the map scale and can be expressed as:

$$PSR = \frac{1}{PS} = \frac{GD}{PD}$$

$$MSR = \frac{1}{MS} = \frac{GD}{MD}$$

Worked Example: Assume that, the distance between two points it was measured to be 83.33mm on a vertical photograph and 125.00mm on a map.

If the surveying ground distance between the same two points is 3000m, what are the scales and the scale reciprocals of the photograph and the map?

Solution:

$$PS = \frac{83.33 MM}{3000 \times 1000 MM} = 1{:}36\,000$$

$$MS = \frac{125 MM}{3000 \times 1000 MM} = 1{:}24\,000$$

$$PSR = \frac{1}{PS} = \frac{1}{1/36000} = 36\,000$$

$$MSR = \frac{1}{MS} = \frac{1}{1/24000} = 24\,000$$

2. Scale from focal length and flying height.

Generally, a photograph is annotated with information, including the date and time of acquisition, the project code, the serial identification of the photograph (i.e. line number and exposure number), the focal length, the flying altitude of the aircraft above Mean Sea Level or above datum.

When these parameters are present, the photo scale may be determined using the same geometry of a vertical aerial photograph from similar triangle any one can write:

$$PS = \frac{f}{H - h}$$

Where: PS is the photo scale, **f** is the focal length of the camera used to take the photograph, and **H-h** is the flying altitude of the aircraft above the ground, which may be average elevation of the photograph or between points on the photograph, or the elevation of a single point on the ground.

In rugged terrain, the flying height values may not represent an accurate values for the project area, since the flying height values may not represent an accurate values for the project area, the photograph, since the flying height printed on the photographs is only a nominal (usually the average) values for the entire project.

This is why the photo-or-project-scale is usually referred to as nominal rather than true scale. Only maps are supposed to have a true scale and they can be very useful in determining photo scale as well.

3. Scale from photo and map measurements

If information on the photograph and the ground distance between two points are not available, the photo scale can still be determined if map of the area is available.

$$GD = PD \times PSR \text{ and } GD = MD \times MSR$$
$$\text{If that: } PR \times PSR = MD \times MSP$$

$$PS = \frac{PD}{MD \times MSR}$$

PD and **MD** are distances measured between the same two points that are well identified on the photograph and the map respectively. E.g. if the distance between the same two points A' and B' were measured and **4.25cm** on a **7.5 minutes** USGS quadrangle (**PRS = 24, 000**), then the scale of the photograph (**PS**) would be **6.05, (4.25*24, 000) = 1:16860**.

4. Scale from an existing aerial photograph

This situation requires that either the scale or the focal length and the flying height above the ground of a second photograph are known. When the scale of a second photograph (PS_2) is known, our photo scale (PS_1) may be determined in the same manner as it was done using a map. By measuring the distances between the same two points on $photo_1$ (PD_1) and $photo_2$ (PD_2), the

unknown scale of photo₁ (PS₁) may be determined from the known scale of photo₂ (PS₂) as:

$$PS1 = \frac{PD1}{PD2 \times PSR2}$$

Where:
PS1 = is the scale to be determined for the photograph (considered as photo1)
PD1 = is the distance measured between well identified points on photo1
PD2 = is the distance measured between the same two points on the known scale photograph (photo2) and,
PSR2 = is the scale reciprocal of photo2.

If the scale of photo2 is not known but the focal length and flying height above the ground are available, then, the scale of photo1 may be determined as follows:

$$PSR2 = \frac{H - h2}{f2} \quad \text{(Then substitute)}$$

$$PS1 \frac{PD1 \times f2}{PD2 \times (H - h2)}$$

Where: *f2* is the focal length of camera used to take photo2 and *H-h2* is the flying height of the aircraft above the ground of photo2.

Procedures of Determining Scales for a Single Photograph

If the information usually printed on an aerial photograph is missing but a map of the area or ground measurements are available, the average scale of a single photograph may be determined as follows:

a) Select two points, preferably at the average ground elevation of the photograph, and approximately equidistant from and opposite the

photo Centre. The two points must be accurately be located on map or on the ground if a map is not available,

b) Accurately (to nearest 0.1mm) measures the distance between the two points on the photograph and the map or determine the ground horizontal distance (to nearest 1m) if a map is not available.

c) Compute the photo scale using equation provided earlier even to the map scale in relation to the ground measurement.

Worked examples:
1. Two points were clearly identified on an aerial photograph and on a 1:24 000 scale USGS topographic map of the same area. The distance on the photograph between two points was measured to be 8.25cm and the same point was measured to be 5.72cm. Find the scale of the photograph.

Solution:

$$PS = \frac{PD}{MD \times MSR} = \frac{8.25}{5.72 \times 24\,000} = 1:16640$$

2. Suppose a photograph was taken from 3500m above MSL with a 152.4mm focal length camera as printed on photograph. If the average ground by photograph is 830m above MSL, what is the scale of the photograph?

Solution:

$$PS = \frac{f}{H-h} = \frac{152.4mm}{(3500-830)x\,(1000mm)} = 1:17520$$

3. Suppose that neither a map nor the information on the photograph are available, but the ground distance between two points well identified points is known to be 1320m and the distance measured on the photograph between the same two points is measured to be 7.86cm. Find the scale of the photograph.

Solution:

$$PS = \frac{PD}{GD} = \frac{7.86cm}{(1320) \times (1000cm)} = 1:16800$$

Procedures of Determining Scale for a Series of Photographs

The average scale for the entire project or series of photographs may be determined as follows:
- a) Determine the average elevation for each flight line using a topographic map,
- b) Compute the average altitude for the area considered using the average altitude determined in step (a),
- c) If H and f are known, otherwise, use the same steps as in the case of a single photograph by considering the average elevation of a set of photograph instead of one single photograph.

Worked examples:

1. A 305mm focal length was used to take aerial photographs from 4000m MSL. Using a topographic map, the average elevations of the flight lines were found to be 700m for line1, 580m for line2, 650m for line3, and 750 Of the project.

Solution:

First, the average elevation of the entire are is determined as:

$$h = \frac{700 + 650 + 750 + 580}{4} = 670$$

Then, using equation, the average scale of the project can be obtained as:

$$PS = \frac{f}{(H-h)} = \frac{0.305m}{(4000-670)m} = 1:10920$$

2. In example 1, the information (H and f) on the photographs was missing but numbers of surveying benchmark were identified on the photographs and topographic map of the same area. Two benchmark points were identified on line1 and line4 and their coordinates were found to be $F_A = 518,000m$, $P_A = 5,182,000m$, $F_B = 515,000m$; and $P_B = 5,179,000m$. By properly overlapping (mosaiquing) the photographs and measuring the photo distance between these two points, it was found to be 26.5cm. Find the average scale of the project.

Solution:

To be able to find the photo scale, we first need to determine the ground distance between the two points. Since known that the ground and coordinates, the distance between the two points may be determined using the Pythagorean Theorem:

$$GD = \sqrt{(FA - FB)^2 + (PA - PB)^2}$$

$$GD = \sqrt{(518000 - 515000)^2 + (5182000 - 5179000)^2}$$

$$GD = 4242.64m$$

Then, using equation, the photo scale can be:

$$PS = \frac{0.265m}{4242.64m} = 1:16,000$$

Another alternative is to compare known areas on the ground to their imaged areas or the photograph. The area ratio is directly proportional to the square of the photo scale. This later may be determined as follows:

$$PS = \frac{PD}{GD} \quad Therefore, \quad PS^2 = \frac{PD^2}{GD^2}$$

$$It\ follows\ that, \quad PS^2 = \frac{Photo\ area}{Ground\ area}$$

$$\text{and} \quad PS = \sqrt{\frac{Photo\ area}{Ground\ area}}$$

3. A rectangular corn field was identified on an aerial photograph and its length and width were measured to be 10cm and 6.5cm, respectively. The ground area of the field is known to be 4 hectares. Find the scale of the photograph.

Solution:
The area of the field on the photograph is computed as:

Photo area = 10cm x 6.5cm = 65cm²

Remember that, in order to find PS, both photo area and ground area must be expressed in the same units. There are 100, 000,000cm² in a hectare (or 6, 272, 640 I square in an acre and 2.4 71 acres in hectares). ***Then, using equation, we obtain as follows:***

$$PS = \sqrt{\frac{65cm^2}{4ha}} = \sqrt{\frac{65cm^2}{4 \times 100,000,000cm^2}} = 1:2480$$

Factors Affecting (Distorting) Vertical Aerial Scale

Scale distortion is the variation in distance between photograph and the actual ground represented from foresight to back sight in ground and oblique photograph from the center towards other sides on aerial photograph.

The causes distortion of scales in both three types of photograph (ground, oblique and aerial) are *image displacement, height of an object on the photo* and *position of an object on the photo*. Therefore, the following are the causes of scale distortion (factors affecting) on vertical scale:

1. Effects of focal length on photo scale: A larger focal length given will produce a larger photo scale; because, the focal length increases even the proportion of

the focal length to the flight height, to the ground distance increases and vice versa.

2. Effects of flying height on the photo scale: A higher flight flying altitudes will produce smaller scales. This is due to the flying height above the ground increases, the proportion of the focal length to the flying height (photo distance to ground distance) decreases.

3. Effect of tilt on the photo scale: This is caused by the tilt of the optical axis of the camera from the vertical at the time of exposure. When the angle between the camera axis and the vertical increases, the distance from the camera to the ground increases also and the proportion of the focal length to this distance (or photo distance to the ground distance) decreases, hence the photo scale decreases.

4. Effect of the topography on the scale: The differences of terrain are a major source of the aerial photo scale variation. This difference in ground elevation causes the flying height above the terrain to vary from one photograph to another or from one point to another in a single photograph. Note that, the focal length *(f)* and flying height *(H-h)* above mean sea level *(AMSL)* remain constant on an aerial photo mission, but the flying height above the ground features varies as the ground elevation changes.

The Effects of the Photographic Scale:

1. The scale of the photograph tends to affect the ground surface coverage, because the large scales of photographs cover small areas on the ground and vice versa.

2. There is high cost when the large scale photographs are involved in taking the detailed amount of information to large ground surface.

3. The size of ground surface covered by the aerial photograph dictates the amount of details depicted on the photograph.

4. It would take more photographs to cover the same area with large scale than small scale photographs.

FRANK PHILEMON

TRIAL QUESTIONS

1. Compare and contrast between:
 a) Aerial and oblique photographs.
 b) Ground and oblique photographs.
 c) Ground and aerial photographs.
 d) Map and Photographs.

2. Describe the characteristics of:
 a) Ground photographs.
 b) Oblique photographs.
 c) Aerial photographs.

3. Discuss the as the source of information
 a) Oblique photographs.
 b) Ground photographs.
 c) Aerial photographs.

4. Draw and show parts of a camera.

5. Write short notes on the following:
 a) Ground photographs.
 b) Oblique photographs.
 c) Aerial photographs.
 d) Satellite photographs.

6. Briefly, write short notes on:
 a) Foreground.
 b) Back ground.
 c) Middle ground.

7. With the aid of diagram, explain the three (3) types of photographs.

8. Use any photograph, and then answer the given questions:

a) What type of photograph is that?
b) Describe the relief of the area shown on the photograph
c) What other non-economic type of land use shown on the photograph.
d) State the land use you have named in (a) above to the environment.
e) Using evidence from the photograph, describe the climatic condition of the area.
f) Suggest the possible human activities can be carried out in the area, Give reason for your suggestions.

REFERENCES

Birch, T.W, (1971). *African Map and Photo Reading*. London: Cox & Wyman Ltd.

Lodha, R. M, (2010). *Academics Dictionary of Geography*. New Delhi: Academic Publishers.

Ministry of Education, (1997). Curriculum, Planning and Development Division, *Understanding Geography*. Singapore: Ministry of Education.

Pritchard J. M, (1990). *Practical geography for Africa*. Hong Kong: Longman Group (FE) Ltd.

Pritchard J. M, (1979). *Africa: A study of geography for advanced students*. London: Longman Group Ltd.

T.I.E, (1996). *Social Studies for Secondary Schools Book Four*. Dar es Salaam: Ruvu Publishers Co. Ltd.

www.ingramcontent.com/pod-product-compliance
Lightning Source LLC
Chambersburg PA
CBHW020708180526
45163CB00008B/2987